SUKIE IS THE UK-BASED DESIGN STUDIO OF
DARRELL AND JULIA GIBBS. THEIR PASSION
FOR PRINTED EPHEMERA INSPIRES COLORFUL
DESIGNS FOR A WIDE ARRAY OF STATIONERY,
TEXTILES, AND GIFTS. WWW.SUKIE.CO.UK

ISBN 978-1-4521-4585-3

Silk-screened printed cover.
Manufactured in China

Design by Sukie

See the full range of Sukie and Rescued Paper
gift products at www.chroniclebooks.com.

10 9 8 7 6 5 4 3 2 1

CHRONICLE BOOKS
680 SECOND STREET
SAN FRANCISCO, CA 94107
WWW.CHRONICLEBOOKS.COM